BANKSY MYTHS & LEGENDS

2

ANOTHER COLLECTION OF

THE UNBELIEVABLE

AND THE INCREDIBLE

BY MARC LEVERTON

T0153554

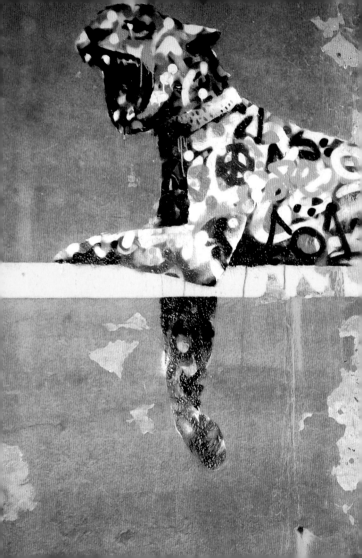

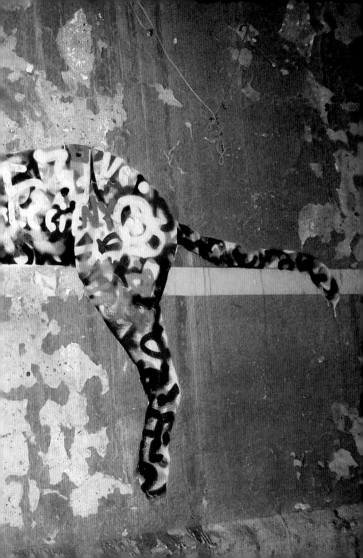

First published in Great Britain 2015
by Carpet Bombing Culture
email: books@carpetbombingculture.co.uk
www.carpetbombingculture.co.uk
ISBN 978-1-908211-31-6

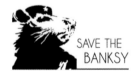

SAVE THE
BANKSY

BANKSY MYTHS & LEGENDS

VOLUME 2

ANOTHER COLLECTION OF

THE UNBELIEVABLE

AND THE INCREDIBLE

BY MARC LEVERTON

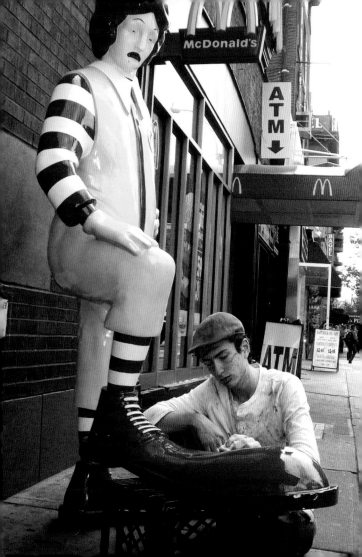

CONTENTS

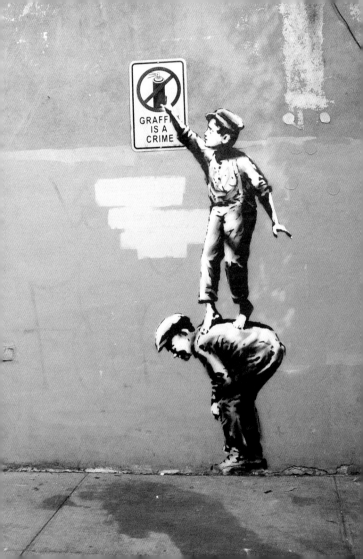

Many elements come together to create the Banksy 'phenomenon'. Art, politics, satire, comedy, surrealism, situationism, celebrity, crime and of course, enough speculation and half truth to fill a tabloid newspaper.

This book focuses on what happens once Banksy's work has left the spray can. Sometimes the reactions can be inspiring and beautiful, quite often it is the opposite. Most art sits on a wall and is contemplated over by art students or pretentious gits. Banksy inspires normal people to make their own art, or to concoct some unlikely theory about what the work is 'saying'. Or, on the other hand, they can be inspired to throw paint stripper over the work. Whatever happens, it is never boring.

Perhaps another part of the Banksy phenomenon is that it is hard to define what it all means. Is it a reflection of 21st century culture in the internet age? Is that the point? What is 'meaning' anyway?

Whatever. Frankly, if you are searching for meaning in a book about Banksy then you are in the wrong section of the book store. Try the new age section. Enjoy these stories for what they are, good stories that we want to be true.

Marc Leverton, Bristol, 2015.

BETTER OUT THAN IN

(#BANKSYNY)

It's 2013, Banksy has been keeping a low profile since his 2011 grammy award nominated movie Exit Through The Gift Shop. Many people speculated that 'Peak Banksy' had been and gone. He'd taken things as far as they could go, achieved so much but was now burnt out by the experience.

Is there a better way to mark your comeback than with a massive, unauthorized outdoor exhibition in one of the busiest cities in the world? Combining elements of classic hip-hop graffiti, political comment, comedy, performance art and of course the accompanying media circus...and a massive, month long game of hide and seek.

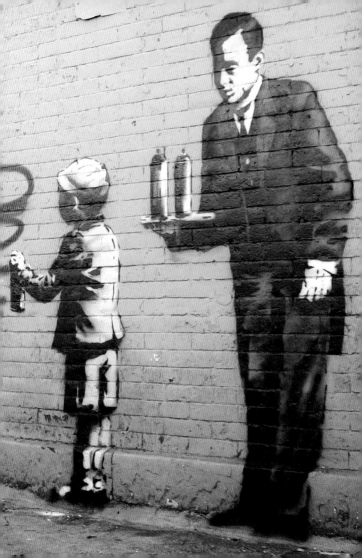

New York state of mind

On the surface it appears that the choice of NYC is straight forward - it is the birth place of graffiti. Plus for this kind of event, getting around on foot is essential.

But, the NYPD also have the notorious 'Vandal Squad' who have been jumping onto the backs of graffiti artists for years. Plus, wasn't he there before with the Pet Store show of 2008? Why would he go back?

One suggestion was that some of Banksy's greatest influences hail from the city; Keith Haring, Basquiat and Warhol all found fame in New York. Banksy suggested that it was because it is home to the best pizza.

Another theory was that NYC based artists invited him to come to the city with the aim of staging a 'resistance' to Mayor Bloomberg. A man who made his millions on Wall Street and also had the Occupy movement forcibly removed from the same location.

Banksy vs The Man

Banksy is no stranger to the strong long arm of the law, and has become quite adept at avoiding it. But even he was surprised by the ferociousness of the NYPD, whose public face may have seemed light-hearted. Bugging the artists transport, harassing hired actors and drivers, and even raiding over 30 apartments where they thought the artist and his crew might be hiding out. The use of bugging equipment also led to conspiracy theories that more senior levels of the man might be involved such as the CIA or the FBI.

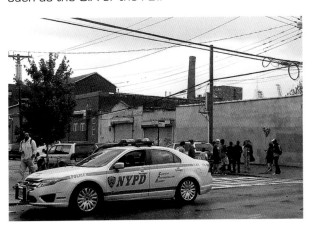

Money trouble

Legendary underground paper The Village Voice publish the first Banksy interview in a very long time. In it Banksy hints that he may have to abandon 'commercial art' in order to regain credibility for his work. Famously frosty with commercial galleries, Banksy tries to keep his work free and for the masses. So how did he fund 'Better Out Than In'? One rumour circulates that the artist threw all his money into 'Exit Through The Gift Shop', and then had to wait two years for the profits to pay out to put into this new project.

Unreliable narrator

The internet and social media is a conundrum which gets right to the dark heart of the Banksy phenomenon. Some critics have suggested that without the internet Banksy couldn't and wouldn't exist. The internet and latterly social media have allowed him to circumnavigate the established artworld of curators and gallery owners.

The Banksy.co.uk site has been in operation since the early 2000s, well before he was internationally famous, which would certainly make him an early adopter of the technology. Yet the Banksy camp has consistently denied that any of the various Facebook accounts, Twitter or Instagram accounts are genuine.

The #BanksyNY Twitter feed which seemed such a reliable source during the residency never had the 'blue tick' of a verified account. The Instagram account was never 'confirmed or denied'.

In a world where everything happens online, Banksy proves there is still no substitute for hunting down the pieces and seeing them for real..

Keep on moving

Revealing 30 pieces over the month of October required a lot of planning and stealth work from Team Banksy. So how did they stay ahead of the man and nosey New Yorkers? One theory suggested that Banksy pre-prepared a lot of the work beforehand, then concealed it prior to the 'reveal' on the day. This led others to speculate that there may have been other pieces that weren't revealed, or were scrubbed before they could be revealed....had a grander finale been planned?

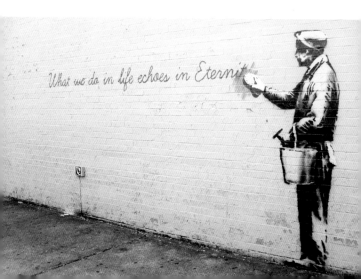

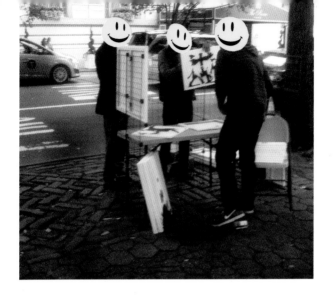

Faked off

Artist Dave Cicirelli sells his own fake 'fake Banksy's' in Central Park just 8 days after Banksy's own fake sale. Determined not to be suckered again the NY public snap them all up. Making Cicirelli more money ($400) than Banksy did himself ($60). Cicirelli even provides his own certificate of inauthenticity. The above image shows unidentified market traders setting up the fake Banksy stall. The 'real' fake fake one...

Less than a year later the two pieces from the real 'fake Banksy' sale, bought for $60 for the pair, fetch over $125,000. Confused? Fake it.

Vive la revolution!

As the New York residency ends there is a flurry of excitement as 'BanksyParis' picks up where Banksy NYC left off. Could this be an audacious attempt by Banksy to do some kind of 'world tour'? But something is amiss. Whoever the pranksters were that created the site, they run out of steam on day 3...sacre bleu (or insert your own French cliche here).

Stunt doubles

Quick draw mobile phone users think they have snapped Banksy: first driving the slaughter lorry, later jumping out of a different lorry, again at a warehouse. However, employing a number of 'stunt doubles' the 'real Banksy' directs the action from a safe distance. The stunt doubles are employed from an agency that specialise in security work in Iraq, trained never to give away any information, even under torture.

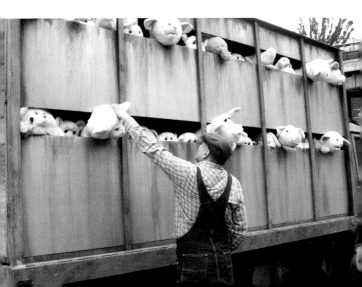

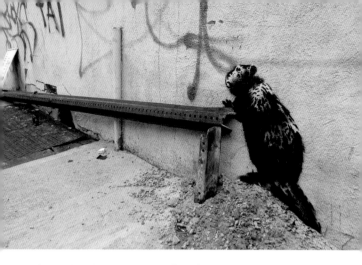

I need a dollar, dollar. A dollar is what I need

'I could step on this shit, it don't matter to me'. So said the gentleman who covered Banksy's Day Ten piece, a Beaver that had gnawed through a street sign. Charging $20 a time to see the piece, the local 'hoods' hid the piece behind a pizza box and a kids BMX.

The guys responsible were reported in a variety of ways, to some they were 'East NY hoodlums' and 'hustlers' who had caused 'outrage'; to others they were 'entrepreneurs'. The irony of being charged to see a Banksy on the street was quickly pointed out, and led to speculation that Banksy had employed the gang to play a part. Sources close to the artist confirm that the gang was indeed acting under their own volition.

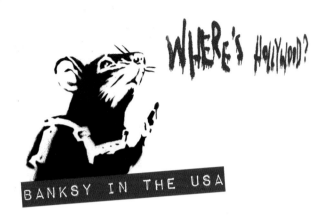

BANKSY IN THE USA

California dreaming

It is often cited that Banksy's first show in the US was LA's celeb fest 'Barely Legal'. But a small gallery in LA called 33 1/3 put on the 'Existentialism' show back in 2002. That year several street pieces appear along the West Coast starting up in Seattle, down to San Francisco and LA.

It has been said that Banksy hitch hiked and bussed down the coast, staying in hostels and motels and occasionally with other artists or with people he met along the way. Maybe you gave a young British artist a lift back in the day?

Just four years later and the artists' fortunes had risen so much, he was able to ship out numerous artworks, staff and even hire a movie elephant.

Taking the Mickey

Banksy has used Disney characters in his work several times, for a Greenpeace campaign in the early noughties and more recently Dumbo was blasted from the skies in the 'Rocket Missile' animation. Dumbo was also later reincarnated into some limited prints which you probably can't afford.

The irony in the whole story? Disney subsequently released their own 'street art' inspired merchandise range. Backatcha!

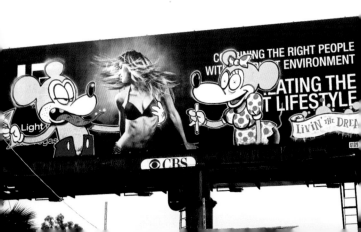

Stick up job

It is often said by pompous Brits that Americans don't understand irony. US chain store WalMart set out to disprove this when they were rumoured to be setting up a deal to sell Banksy prints. Not official prints, but fake prints of Banksy's work. An additional layer of irony was added when it was revealed that one of the pieces on sale was 'Destroy Capitalism' (not pictured btw, this is Thai Banksy).

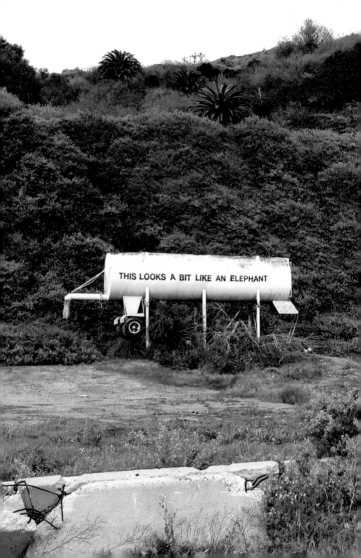

Looks a bit like...a bloke from EastEnders

'Looks a bit like an elephant' is a clever bit of word play, quickly tagged along the side of a water tank in LA. This piece was to set in motion a bizarre series of events.

Unbeknown to Banksy there was a man living inside the water tank. The man turns out to be a very interesting chap called Tachowa Covington who occasionally roller skates around LA dressed as the Statue of Liberty wearing a kilt.

Tachowa had been living in the tank anonymously for 7 years. Once attention is drawn to the resident he is evicted. It is illegal to be homeless in LA and to add insult to injury an 'arts organisation' buys the tank.

The story goes that Banksy felt guilty at making a homeless man even more homeless, so he gave Tachowa enough money to live on 'for a year'. A rumour also circulates that Banksy buys back the water tank and has it melted down. Another rumour is that the tank is still sitting in a warehouse with the owner waiting for the story to settle before making any attempt to cash in.

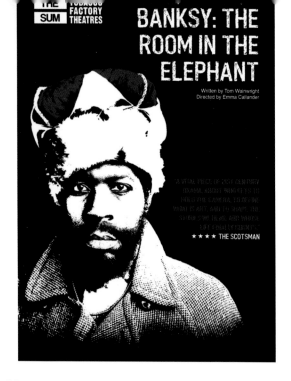

THE SUM / TOBACCO FACTORY THEATRES

BANKSY: THE ROOM IN THE ELEPHANT

Written by Tom Wainwright
Directed by Emma Callander

'A VITAL PIECE OF 21ST CENTURY DRAMA, ABOUT WHO GETS TO HOLD THE CAMERA, TO DEFINE WHAT IS ART, AND TO SHAPE THE STORIES WE TELL, AND WHOSE LIFE FINALLY COUNTS"

★ ★ ★ ★ THE SCOTSMAN

Meanwhile, back in Bristol a young playwright called Tom Wainwright is inspired to write a play about Tachowa. Before you know it, Tachowa is no longer living in the tank but is at the Edinburgh Fringe Festival meeting the actor who is playing him, who used to be in British soap opera Eastenders.

On a mission

In 2010, Banksy ripped through San Francisco leaving behind several street pieces including a rat holding a fat marker pen.

The piece is defaced, restored and then the owner of the house is ordered to have it removed by city authorities, who incidentally spend $20 million removing graffiti each year.

Local documentary maker Brian Greif jumps in and has the piece cut out. Not to sell it, but to preserve it. 'Yeah right' cry the cynics. But despite being offered sums of over $500,000 Greif sets up a Kickstarter campaign asking for $10,000 to 'Save the Banksy' and have it preserved in the city for all to enjoy. The target is quickly reached. Is this a glimpse of the future?

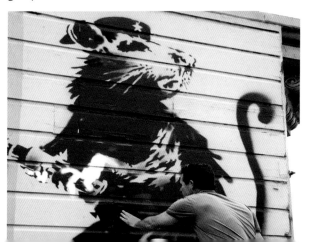

Plane stupid

Banksy has painted a lot of things other than walls and canvases. The list includes trucks, vans, buses, tattoo parlours, hotels, circus attractions, record covers, placards, bridges, advertising hoardings, portaloos, sheep and cows.

However, when Banksy received a generous commission request by one of the Murdoch family to paint their private jet, unsurprisingly he turns the business moguls down.

THE RISE AND RISE OF BANKSY

Banksy's rise to fame includes many classic tales which as time passes, become harder and harder to verify. Rest assured dear reader that the authors of this book have done little to unprove these myths.

Tipped off

During the 2010 trip to San Francisco one of Banksy's team gets permission from a waiter to climb on top of a restaurant roof. There is a delay whilst a neighbouring rooftop finishes their party and then Banksy hops up and the deed is done.

The next day the team learn that the waiter has been sacked for his misdemeanour. Hearing of this injustice Banksy knocks out a signed personalised piece on a nearby discarded street sign. It is not yet known what the waiter did with the piece.

Is this the oldest Banksy piece still in existence?

The Barton Hill Youth Club in Bristol is where Inkie, Cheo, Banksy and many others had the freedom to paint with the encouragement of youth worker John Nation in the late 80s.

This piece appears to depict a poodles head on a bulldogs body, along with the distinctive tag above. In 2012, graduates of the 'Barton Hill School of Art' returned to paint some new pieces and discovered the rain had washed away some of the newer pieces revealing this Banksy piece which could be about 15 years old.

A similar piece was also discovered in Manchester's Northern Quarter.

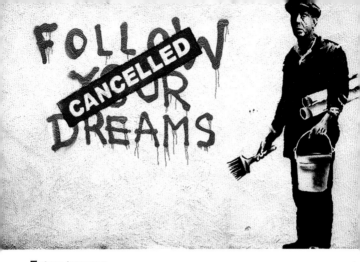

Extra tenner

Much like today the UK in the 90s was rife with youth unemployment. What many people did was work for cash *and* claim benefits. The unemployment office on Nelson Street in Bristol (now a bowling alley) was where Bristolians had to 'sign on' in order to receive their money.

After a year or two of claiming benefits, youngsters were often put on Employment Training courses (ET), often these were in local community centres in dodgy parts of town. Banksy is said to have attended one such course for while but was sacked for not writing a business plan for his painting and decorating business.

Lessons in Banksy

It was once Network Rail policy to remove all graffiti found on its premises. In 2007 Pulp Fiction was removed ('valued' at £250,000) and later that year they removed another piece of a monkey blowing up a bunch of bananas behind Waterloo station. It was then decided that rail staff needed to know what was potentially valuable, and so the graffiti removal team were sent to specially arranged 'Banksy classes' to learn what was worth saving (ie a Banksy) and what could be scrubbed (everything else).

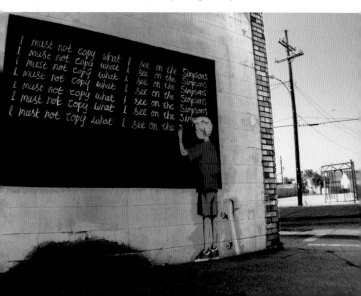

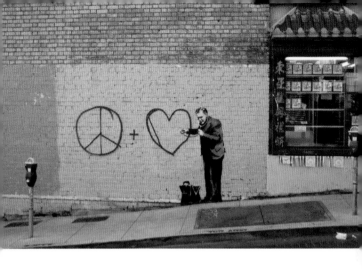

University of life

At the height of Banksy mania, Pest Control (Banksy's artwork verification outfit) were receiving so many requests for information from art students doing their dissertations on Banksy, that they had to find an intern whose job it was to deal with them. Meanwhile at a University in Bristol, the entire topic of street art is banned by lecturers fed up with marking countless essays on Banksy. But as hundreds of students move to the city, because of its link with Banksy, one of the Universities tries to offer him an honorary degree. He turns it down.

A very British protest

During the 2003 Turf War exhibition Banksy exhibits tagged pigs, sheeps and cows. Does someone in the camp alert animal welfare campaigners to the goings on? If they do, it works. An animal rights protestor promptly arrives at the exhibition and chains herself to the railings of the animal pen. Spotting that she doesn't fully secure herself Banksy's crew keep quiet about it not wishing to offend her stand. They made her cups of tea and she leaves quietly at the end of the day.

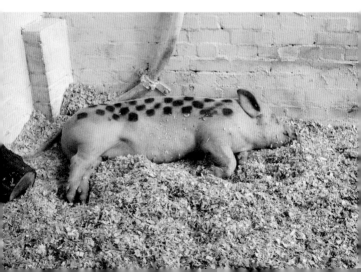

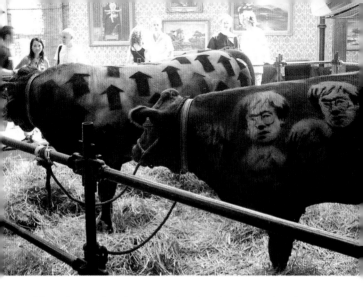

Elsewhere the farmer who lends the animals to Banksy for Turf War is under the misapprehension that the artist is going to paint a picture of the cows on canvas, not literally *paint the cows*.

Cans Festival

A disused railway tunnel in Leake Street, Waterloo, SE London is turned into a half-mile long exhibition space. Banksy gets together with 29 other international street artists for a 'Stencil Art Street Battle' to 'transform a dark forgotten filth pit' into 'an oasis of beautiful art'.

The event is organised in upmost secrecy. The rumour is that Banksy sends first class plane tickets to selected artists with only an address and a date. They have no other details of what is planned. Despite this, all the artists are present at the allotted hour.

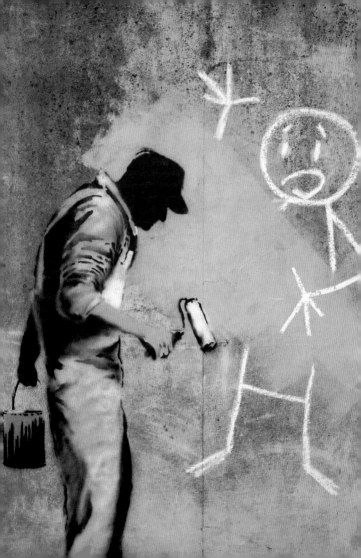

Decorating the bathroom

Early on in his career Banksy uses the guise of a painter and decorator, using a Mr Whitewash sign nicked off a building site.

Banksy is also rumoured to have painted the bathroom of Kate Moss's Hampstead pad, did he create a one-off of her Warhol inspired portrait? Or did he just do her a favour and put up a shower rail?

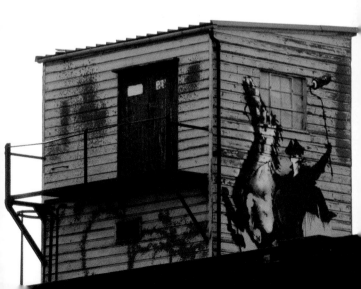

> ## "THE BAD ARTISTS IMITATE, THE GREAT ARTISTS STEAL."

~~PABLO PICASSO~~
BANKSY

EVERYTHING IS A REMIX

Much has been made of Banksy's influences, and he has been accused of ripping off artists such as Andy Warhol and Blek Le Rat. In his defence fans point out that Graffiti is a key component of the early hip-hop pioneers crew, which also comprises of a DJ, B-boys and an MC.

Hip Hop is an art form that takes parts of old music and remixes it to create something new. This idea is also at the heart of myths and legends - which are stories retold time after time, inevitably changing each time. Banksy has self-mockingly referenced this paradox above.

One Nation

Listing influences oversimplifies things. But it is worth noting that Banksy grew up during the political strife of the 80s with its races riots, miners' strikes and the poll tax riots.

On page 30 we mentioned the importance of Barton Hill Youth Club and youth worker John Nation. In the book Children of the Can, Banksy says "John Nation, that shouty, red-faced, little social worker who made it all happen, has had more impact on the shape of British culture over the last 20 years than anyone else to come from the city."

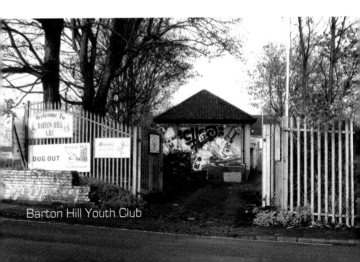

Barton Hill Youth Club

TRIBUTE ACTS

Tats Crew

Banksy's work has been appropriated by fans in all sorts of ways - for vehicles, crappy decorative 'wall stickers', cross stich patterns, underwear, nail art.

Several years ago Banksy's own website used to have a gallery of pictures that fans had sent in of Banksy tattoos. What better way to demonstrate your admiration for the work of an artist who specialises in temporary art than with something permanent. Pity the poor fools who had tattoos of Banksy copyists such as 'girl with hearts' or 'suicidal panda'. Tut, tut, goes to show you should always do your...whachamacallit...research.

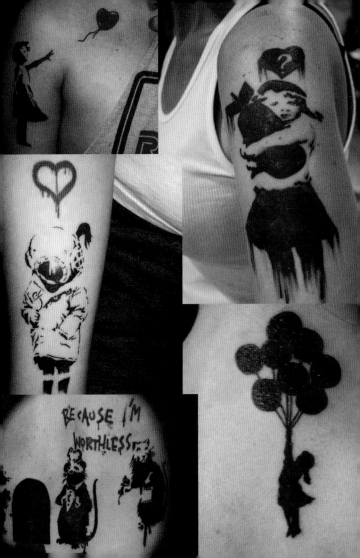

Taxi for Banksy

The internet has allowed 'fan art' to reach a far bigger audience than just your mates in the pub. These Banksy inspired taxidermy rats are being sold on eBay by Glaswegian artists Lillian and Vic Gallagher. Lil says 'I have always admired and followed Banksy's work, especially his rats. As I could not afford to buy any prints, and not wanting a cheap knock off, I decided to learn taxidermy to make a 3D toxic spill rat. I was soon asked to do more and it has grown from there, now we have our own small group of followers and collectors'. Follow Taxidermy Newtyouall on facebook.

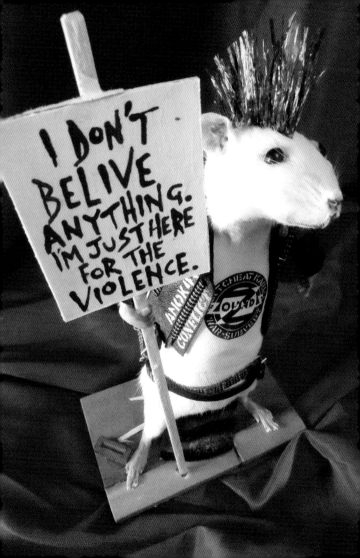

Blotters

Blotters are another term for LSD or acid, a drug popular with hippies in the 60s. The small bits of blotting paper produce mind altering 'trips' where the users can either experience profound feelings of love and joy or a 'bad trip' could result in paranoia and hallucinations.

The designs have been popular with collectors for years and often carry trippy images such as rainbows or smiley faces. Banksy's work has been very popular in recent years, even appearing on Banky's own site. BlotterArt.com say that Kate Moss and Flower Thrower (Riot Green) are their most popular.

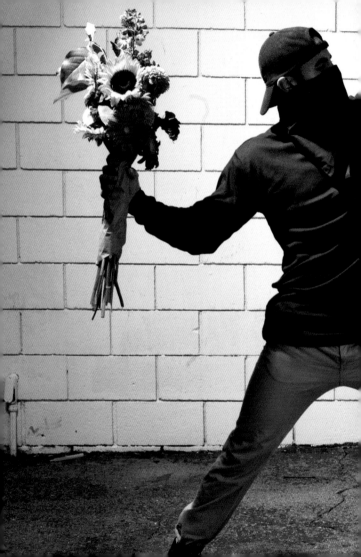

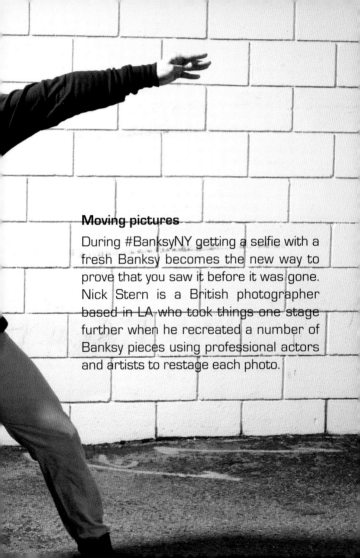

Moving pictures

During #BanksyNY getting a selfie with a fresh Banksy becomes the new way to prove that you saw it before it was gone. Nick Stern is a British photographer based in LA who took things one stage further when he recreated a number of Banksy pieces using professional actors and artists to restage each photo.

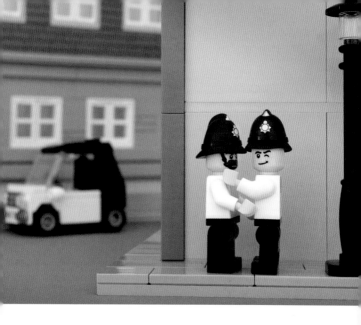

Keep it unreal

Canadian artist Jeff Friesen was playing Lego with his daughter when they came up with the idea to produce scenes inspired by each US state. Their next project was equally ambitious, recreating some of Banksy's best known work.

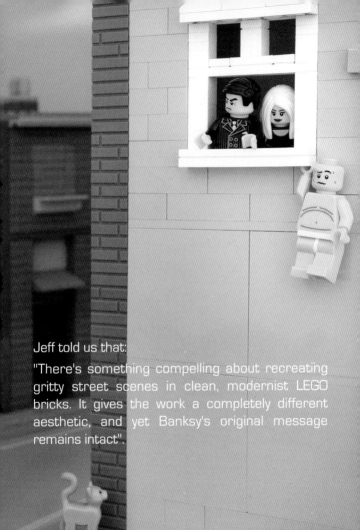

Jeff told us that:

"There's something compelling about recreating gritty street scenes in clean, modernist LEGO bricks. It gives the work a completely different aesthetic, and yet Banksy's original message remains intact".

'THE COME DOWN'
(2011 - 2013)

After the dizzying heights of having had a Hollywood hit, Team Banksy take a self-imposed hiatus. However, there is speculation that Banksy is as prolific as ever but either keeps the work stored up, or continues to operate under different aliases experimenting with different styles and media.

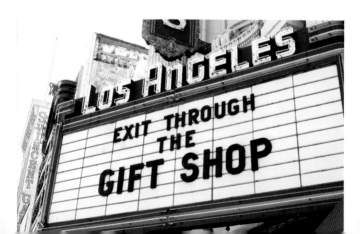

You don't need planning permission to build castles in the sky

A 2012 piece which didn't, and still doesn't, attract much attention is this piece pictured under Bristol library. It had a brief appearance on the Banksy website, which pretty much authenticates it. The phrase doesn't appear too profound at first, but location is a key aspect of Banksy's work.

It is very close to City Hall, could this be another comment on Banksy's old foe Bristol City Council? Or a pop at recent library funding cuts?

Another theory is that there are several schools and colleges nearby, including Bristol Cathedral School and this fairly hidden backstreet is where local kids sneak off for a crafty cigarette. Is this an inspirational message for teenage wasters?

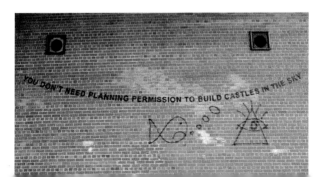

A one hit wonder...

2011 was a bad year for Banksy in Bristol when two iconic pieces were lost. 'Masked Gorilla' was painted over and then some monkey defaced 'Sniper' with Robbo graffiti.

One positive arose in the form of the Aladdin Sane Queen. Using the 'Sniper' site this was strongly denied as being a Banksy and the piece was credited to a previously unheard of artist from Weston-super-Mare called 'Incwel'. Whose website incidentally still only shows the one piece... a website that also follows the same layout as Banksy's.

So unsurprisingly fans assume 'Incwel' is one of Banksy's 'disguises'.

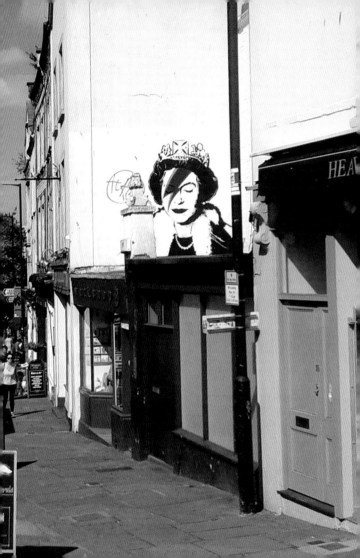

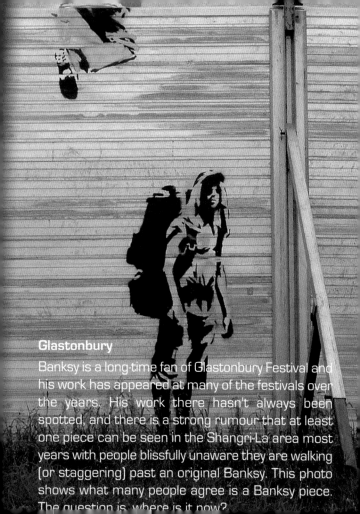

Glastonbury

Banksy is a long-time fan of Glastonbury Festival and his work has appeared at many of the festivals over the years. His work there hasn't always been spotted, and there is a strong rumour that at least one piece can be seen in the Shangri-La area most years with people blissfully unaware they are walking (or staggering) past an original Banksy. This photo shows what many people agree is a Banksy piece. The question is, where is it now?

Michael Eavis

In 2014 the Meat Truck originally seen in New York makes an appearance at the festival. Farmer and Glastonbury founder Michael Eavis responds to questions that this is an animal rights message by pointing out that his cows are 'very happy cows' and have the highest yield of milk production in the UK.

Special Delivery

Banksy rarely gives any personal details away, but might a string of pieces over 2012 and 2013 provide some insight into his personal life?

 The first in this 'trilogy' is 'Bird has got the horn', a bird sits on a tree, but the branch could look like a penis. There was no reply from Banksy sources when we enquired if this was drawn to scale.

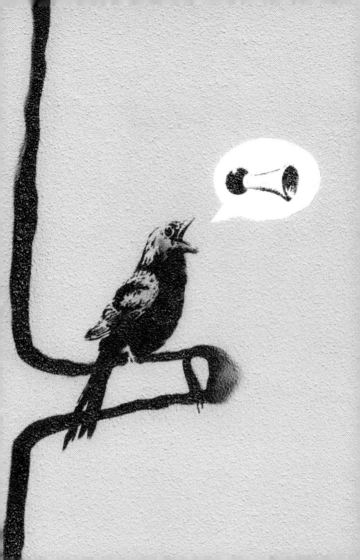

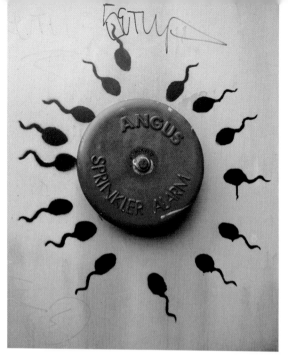

Next up is 'Sperm alarm', another witty piece. Any man with children will be familiar with the sound of this alarm bell ringing. The actual piece itself is quickly removed and then crops up on eBay. Not learning any stealth moves from Banksy himself, the thief lists the piece under his own name, and is immediately caught. Doh. The thief is let off with a caution, however the piece has never been recovered.

In the third and final installment, 'the stork' has arrived on a quiet rivers edge deep within the quiet rural backwater of Tavisock, Devon. The most beautiful of the three pieces, and compared to the first at least, poignant and sensitive too.

To those paying attention to the narrative, any ideas on the symbolism?

GONE, BUT NOT FORGOTTEN

When a Banksy piece leaves the spray can it takes on a life of its own, for better or worse. Sometimes beautiful things happen like we have already seen. Sometimes ugly things happen...

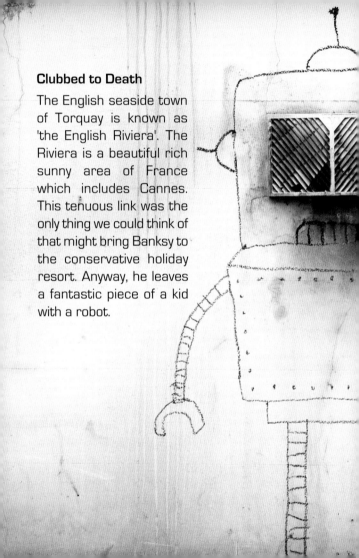

Clubbed to Death

The English seaside town of Torquay is known as 'the English Riviera'. The Riviera is a beautiful rich sunny area of France which includes Cannes. This tenuous link was the only thing we could think of that might bring Banksy to the conservative holiday resort. Anyway, he leaves a fantastic piece of a kid with a robot.

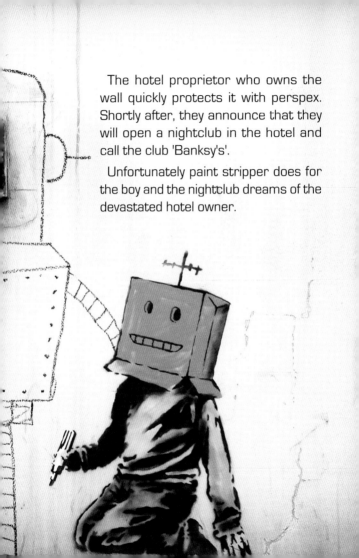

The hotel proprietor who owns the wall quickly protects it with perspex. Shortly after, they announce that they will open a nightclub in the hotel and call the club 'Banksy's'.

Unfortunately paint stripper does for the boy and the nightclub dreams of the devastated hotel owner.

'I am the resurrection'

The People's Republic of Stokes Croft (PRSC) are a collective of artists, based in the 'bohemian' area of Stokes Croft in Bristol. Their mission is to promote cultural diversity and try and hold back the forces of gentrification in the area. Banksy's Petrol Bomb poster was a fund raiser for them and others financially affected by the 'Tesco Riot' in 2011.

Banksy's 'Mild, Mild West' is restored by the collective 'two to three times a year' according to Chris Chalkley who leads the project. He wasn't sure whether he agreed with repairing it on principle but was convinced of the importance after chatting to some random passers by and a few of the street drinkers on Turbo Island. PRSC sell a china mug of Chalkley mid-clean up...

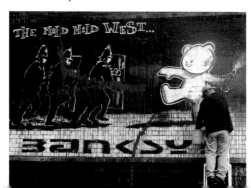

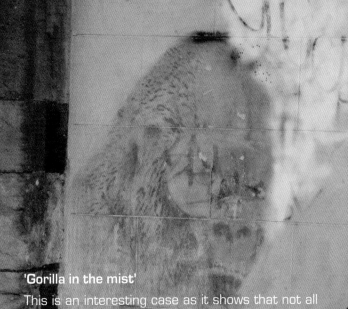

'Gorilla in the mist'

This is an interesting case as it shows that not all pieces are destroyed with malice. Banksy's Pink Gorilla was often held up as the finest example of Banksy's freehand drawing skills as there was no stencil in sight and no words. There are various interpretations of the piece including the idea that the disguise made it a self portrait.

The piece was painted over during the renovations for a Muslim Cultural Centre and Saeed Ahmed, who carried out the act, had no idea who Banksy was. He apologised and tried to have it restored, but today it is only just visible.

Poundland

At the time (2012) the Poundland piece was the first high profile piece stolen from under the publics' nose. 'Ikae punk' and others had gone the same way, but not whilst there was so much public and media attention on the work.

What became apparent with this episode, and would later typify these incidents, is that it was the local community who felt most aggrieved. Viewing the piece as a gift to their area there is a swell of local pride, which is then punctured when the piece is ripped out and sold to a millionaire.

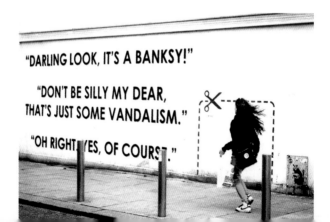

Kisses from Down Under

Brighton's 'Kissing Coppers' has consistently been one of the most well-known and loved pieces since it appeared on the side of the Prince Albert pub in 2004. It was cut out and sold at a Miami auction house in 2014 for £345,000.

What is less known is that the piece was scrubbed earlier in its life. In 2006 two munters chucked paint over the piece for which they received a conditional sentence. Jez, the Australian barman was so upset by the incident that he repainted the piece himself, tracing around the faded image and eventually restoring the piece (almost) to its former glory. What is unknown is whether the new owners knew they were buying a Jez restored Banksy.

ANARCHY IN THE UK (2014)

One nation under CCTV

Cheltenham, an hour north of Bristol is home to Government Communications Headquarters, the British government's 'snooping centre'. Banksy's 'GCHQ' marked a return to high profile street works in the UK in April 2014. It is also a witty response to the recent encroaches on personal freedom by the National Security Agency and their allies.

Predictably, reports quickly surface suggesting that the Banksy piece on the side of Cheltenham house has doubled the price of the property. There are some attempts to tag and deface the piece, which becomes fiercely protected by the local community. One weapon in their defence being CCTV placed on the piece by The Fairview pub opposite.

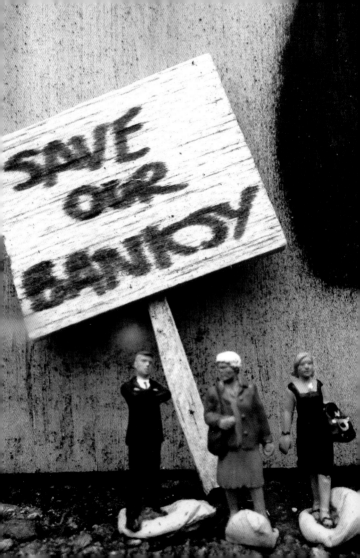

However, even this level of community protection couldn't stop the house owner and a 'gallery' attempting to remove the piece on the opening day of the Glastonbury festival. There is an attempt by local business owners to raise a million pounds and the Council serve a 28 day 'delay notice'. This temporarily preserves the piece behind hoardings (and a mysterious van which is nicknamed 'Vanksy'). At the time of going to press, the piece is back on display but is heavily tagged, much to the dismay of all who tried in vain to preserve the piece.

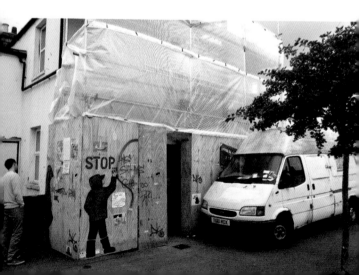

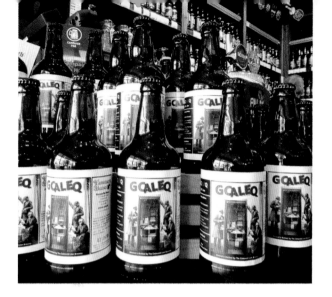

GC 'ALE' Q

Banksy has inspired many by-products, but this 'Banksy beer' from Cheltenham is a first we think. The Cotswold Lion Brewery set an encryption competition to unlock the tasting notes which hint that the ale is 'full of dark secrets'.

The beers are sold in the Favourite Beer shop across the road from the piece. They told us they sold one and a half thousand bottles to thirsty Banksy fans in just the first six weeks. They are currently planning a GC 'Pale Ale' HQ. What next? Banksy peanuts?

Best of British

The general disrepair of the phone box makes a suitable backdrop for the Banksy piece and pictures quickly spread across the world. British Telecom (BT) who look after the phone box are suitably embarrassed and send along Simon and Peter who clean it up.

Two weeks after the piece goes up local couple Paul and Pip Organ get married and pop out mid celebration to get this brilliant snap.

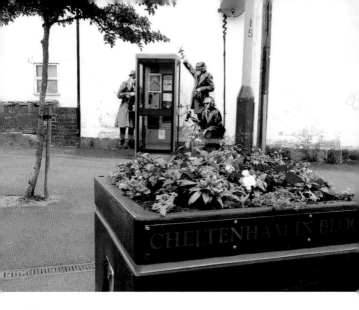

Bloomin 'eck

Cheltenham is a Regency era town (that means its posh) and described as the 'Gateway to the Cotswolds', the average house prices are above the UK national average. How typical then, that Banksy should find one of the very few houses in a state of disrepair. Banksy's street cred is challenged not by other graffiti writers as was the case in NYC, but by the local council who put a nice box of flowers in front of the piece.

Ultimate Endorsement

Appearing on a BBC local radio station, British Prime Minister David Cameron is asked about the GCHQ piece, to which he says: 'I do love this Banksy. It is a remarkable piece of art. He is a genius in many ways'.

These comments leave Banksy fans reaching for the sick bag, joking on Twitter that the artist's work will have dropped in value by 75% after this 'endorsement' from the establishment.

Brandalism

Banksy coined the term 'Brandalism' around the time of the Turf War exhibition. The largest advertising takeover in world history takes place under the same name in June 2014. Teams of guerilla artists stage the takeover of 365 corporate advertising spaces in 10 UK cities. Mostly illuminated bus shelters.

The project saw artworks from 40 international artists installed in public spaces across the UK including Radiohead's cover artist Stanley Donwood and Paul Insect (above).

No Banksy work was included, but that didn't stop people speculating whether he used a pseudonym or if he played a hand in the operation.

www.brandalism.org.uk

Mobile Lovers, part one

'Mobile Lovers' is an attack on the evils of social media and the invasion of technology into our relationships. It is also the first piece by Banksy in Bristol for a number of years. In a lovely twist of irony, the location of the piece was found by someone who claimed to have found the work by using Twitter and Google Street View on their mobile.

As with most Banksy pieces, positioning is crucial. This piece was by the side of the busy M32 motorway which meant it would be widely seen. The piece is also next to a cash-strapped boxing club who quickly prise the piece away from the door it has been fastened to for 'safe keeping'. They suggest that the piece will only be vandalised, plus it must be a gift, why else would Banksy leave it there?

Mobile Lovers, part two

An almighty row ensues between the boxing club, the local media, local people and Banksy fans on social media. Then Bristol's mayor George Ferguson weighs in stating that the piece was put on Bristol City Council property.

A compromise sees the piece find a temporary home in the museum before it is returned to boxing club manager Dennis Stinchcombe MBE, who by this stage has become something of a local celebrity.

Back in Dennis's care things become even more surreal when Dennis is vindicated by a letter reportedly from Banksy. Dennis then takes 'Mobile Lovers' to the Antiques Roadshow to be valued. Fans will remember Banksy pastiched this programme on his Channel Four 'take over' in 2012 with The Antics Roadshow. Stinchcombe even tries to sell it to Richard Branson.

A story goes around that he is offered $4million for the piece (which would have set a new record for a Banksy), but declines it as the offer is from a gallery which specialise in stolen street works. A private buyer is eventually found, but at a much more realistic £400,000.

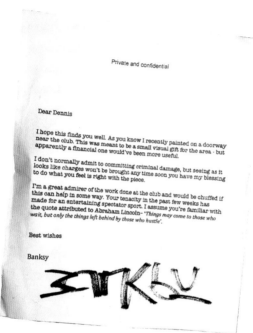

Private and confidential

Dear Dennis

I hope this finds you well. As you know I recently painted on a doorway near the club. This was meant to be a small visual gift for the area - but apparently a financial one would've been more useful.

I don't normally admit to committing criminal damage, but seeing as it looks like charges won't be brought any time soon you have my blessing to do what you feel is right with the piece.

I'm a great admirer of the work done at the club and would be chuffed if this can help in some way. Your tenacity in the past few weeks has made for an entertaining spectator sport. I assume you're familiar with the quote attributed to Abraham Lincoln- *'Things may come to those who wait, but only the things left behind by those who hustle'*.

Best wishes

Banksy

With Syria

Banksy's red balloon girl is used in a poignant video to highlight the third anniversary of the occupation of Syria. This is a rare instance of Banksy 'licensing' an image from work to an outside organisation.

The film is premiered in the US in Times Square, prompting speculation that this was what was originally planned as a finale for #BanksyNY.

Arrested Development

On Monday 20th October 2014 the world woke up to the news that Banksy had been arrested and identified as Paul Horner, 35 from Liverpool. The source was National Report 'America's #1 Independent News Source'. The story ran amok on the internet, reported in much of the mainstream media.

National Report is a satirical website, which even lists Paul Horner as a contributor alongside Lillian Fabricant. Horner it turns out is an aspiring comedian from Arizona. This Banksy story being one of several that he has duped the media with. The four million hits to his website during this hoax apparently netted him $10,000 a day from advertising.

'The Girl with the alarm earring' came out on exactly the same day as the hoax. The press reported the story as being 'Banksy paints Pearl Earring to prove he hasn't been arrested'. But sources close to the piece suggest it was painted over the weekend before the Hoax story had been published. Was this a pre-emptive move to steal back some of the headlines?

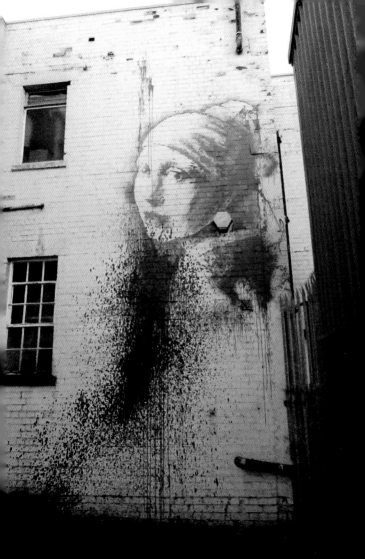

Mystery man

On an unusually warm October weekend a new street piece appears in Bristol, 'Girl with the Alarm Earring'. A couple of students wandering around taking photos are then approached by a man encouraging them to take some pictures of something 'which might be a Banksy', he also encourages them to put the pictures online. No mystery there maybe, but the students also suggest that the man was 'quite old' had a 'fake beard'. And we all know who likes to wear disguises don't we?

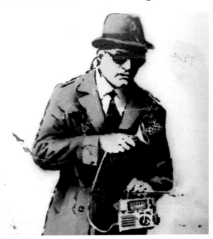

More 'Banksyness'

By early Tuesday someone has chucked black paint over the piece and there are suggestions it might have been the neighbours, cross about all the Banksy fans parking in their spaces. It certainly wasn't the guys from the burger van, or the 'gallery cafe' as Banksy christened it, they are happy with the increased footfall and unveil the 'Banksy Bacon Roll'.

The alarm, which some have suggested is fake, is later caught on CCTV being 'repaired'. The plot thickens when it appears that the repair man is from a rival alarm company and was placing a sticker with his firms logo over the original logo on the alarm.

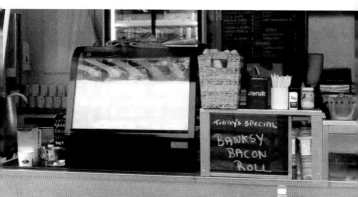

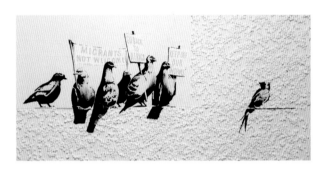

Clacton by-election

When Conservative MP Douglas Carswell defected to the further right-wing party UKIP it triggered a by-election. Banksy's 'Migrant Birds' is a comment on UKIP immigration policies.

The local Council scrub the piece within 24 hours after a complaint is received that the piece is 'offensive' and 'racist'. The British liberal media chuckles for days (even Jonathan Jones the art critic from The Guardian who until this point has never had a kind word to say about Banksy).

Clacton artist Ross Baines is inspired by these events to produce his own 'tribute canvas' to the piece (pictured) which even includes some pebble dash.

In the Buff

Continuing his tour into previously unpainted territories Banksy heads to Folkestone next, which is hosting The Triennial art event.

'Art Buff' shows an elderly lady looking at a plinth with nothing on it. That was until someone sprayed a giant penis on to it. The local council tried in vain to protect the piece with some perspex. But as the old expression goes 'shit talks, money walks' and pantomime villains the Bank Robber Gallery were said to be behind the removal and sale of the work. Locals were upset with the timing of the removal of the piece, which coincided with the last weekend of the art festival. Boo hiss.

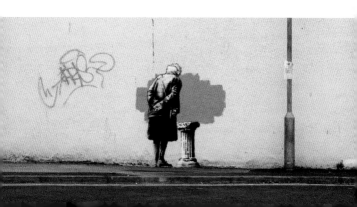

THANKS

Thanks to the following for supplying images:

P2 - Allan Molho / P6 Allan Molho / P8 – Allan Molho / P11 – Allan Molho / P13 - Dana Wada / P14 - Kelly Hafermann / P16 - Alan Molho / P17 - Mike Reed / P19 – Allan Molho / P20 - Dana Wada / P21 - Chris Laskaris / P22 – Lord Jim / P23 - Simon Ellis (Instagram - simonprint) / P24 - Ryan C. Winkleman / P26 - Publicity image for Banksy: The Room in the Elephant (Produced by: Tobacco Factory Theatres, The Sum and Òran Mór. Created by Emma Callander and Tom Wainwright. Written by Tom Wainwright. Image: Graphic Design by Barney Heywood & Photography by Paul Blakemore. Flyer design: Farrows Creative). / P27 - Brien Grief ('Save the Banksy') / P28 – Ian Haskins / P30 - Marc Leverton / P31 – Joe Wolf / P32 – Will Tuft / P33 – El Payo. Creative Commons / P34 – Jonny Baker / P35 – Jonny Baker / P37 – Su Linn / P38 – Rex Dingler / P39 – Eddie Dangerous / P40 - Tony Hisgett / P41 - Marc Leverton / P43 – Lily Shears, Jason Saul, Erokism,

Cayoo, Kill. Used under licence Creative Commons. Attribution-NoDerivs 2.0 Generic / P45 - Vic n Lil (Facebook - 'Taxidermy Newtyouall') / P46 - Blotterart.com / P48 - Nick Stern (nickstern.com) / P50 - Jeff Friesen (thebrickfantastic.com) / P52 - Lord Jim / P53 - Marc Leverton / P54 - Marc Leverton / P55 - Marc Leverton / P56 - Simon Kisner (Instagram - mistersnappy) / P58 – Steve Rhodes / P60 – Annar 50 / P61 – Brian Garwood, www.actualcolour.com / P62 - Lord Jim / P64 - Brian Garwood, www.actualcolour.com / P66 - PRSC (People's Republic of Stokes Croft) / P67 - Marc Leverton / P68 - Bozhidar Chkorev / P69 – Bmiz. Creative Commons / P71 - Marc Leverton / P72 - Marc Leverton / P73 - Marc Leverton / P74 - Ben Roberts (Bloomingphotography.com) / P75 - Marc Leverton / P76 - Andy Webb (www.dreamabstract.com) / P77 - Paul Insect (brandalism.co.uk) / P78 - Sharon Flanagan (Bristol Film Office) / P83 - Marc Leverton / P84 – Marc Leverton / P85

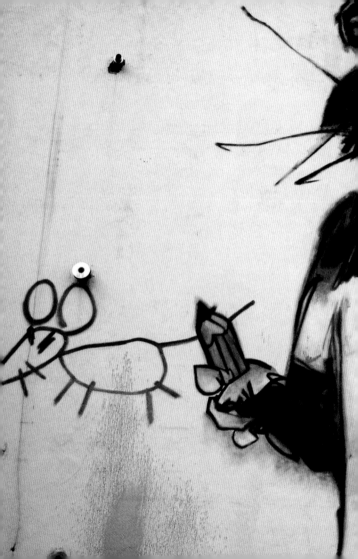

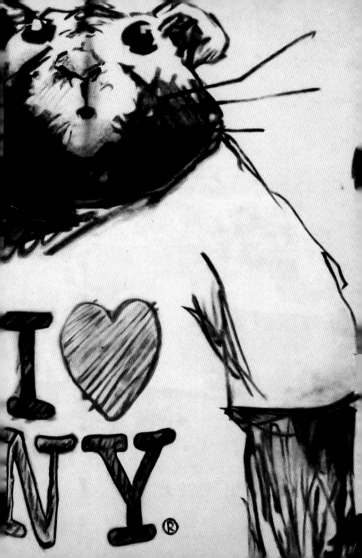

www.carpetbombingculture.co.uk